Rochester

and the State of NEW YORK

It's big
but friendly too!

It's fun
with lots to do!

NEW YORK

Rochester

The places where you live and visit help shape who you become. So find out all you can about the special places around you!

Cool Stuff™

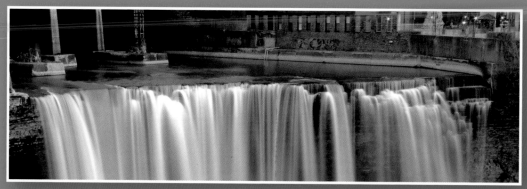

The Genesee River's High Falls

CREDITS

Series Concept and Development
Kate Boehm Jerome

Design
Steve Curtis Design, Inc. (www.SCDchicago.com); Roger Radtke, Todd Nossek

Reviewers and Contributors
Patti Donoghue, VisitRochester; Connie Bodner, PhD, senior researcher;
Judy Elgin Jensen, research and production; Mary L. Heaton, copy editor

Photography
Cover(a), Back Cover(a), i(a), *Spotlight* (a), *Sights and Sounds* (c), *Strange But True* (a), xvi(e) Courtesy VisitRochester; Cover(b), Back Cover(b), i(b) © mrsnstudio/Shutterstock; Cover(c), xvi(d) © Harris Shiffman/Shutterstock; Cover(d), *Marvelous Monikers* (d) © Matt Ryan; ii © Patrick O'Connor/Shutterstock; iii, *Marvelous Monikers* (c), xvi(b) © Mary Shelsby; *Spotlight* (background) © Filipe B. Varela/Shutterstock; *Spotlight* (b) © Martin Pinker; *By The Numbers* (a) Courtesy the Eastman School of Music; *By The Numbers* (b) Courtesy Rochester Children's Theatre; *By The Numbers* (c) Courtesy RMSC/Steve Fentress; *By The Numbers* (d) © Sheridan Vincent; *Sights and Sounds* (a) Courtesy Seabreeze Amusement Park; *Sights and Sounds* (b) Courtesy Zweigle's Inc.; *Sights and Sounds* (d), xvi(g) © Carol Bednar; *Sights and Sounds* (e) Courtesy the National Museum of Play at the Strong™, Rochester, NY; *Sights and Sounds* (f) © duckeesue/Shutterstock; *Sights and Sounds* (g) By T.J. Photography, Rochester, NY/Courtesy Rochester Museum & Science Center; *Strange But True* (b) © Jeff Gerew; *Strange But True* (c) From the Albert R. Stone Negative Collection, Rochester Museum & Science Center, Rochester, NY; *Strange But True* (d) From the collection of the Rochester Museum & Science Center, Rochester, NY; *Marvelous Monikers* (a), xvi(h) Courtesy Wegmans Food Markets; *Marvelous Monikers* (b) © Maria Friske; *Dramatic Days* (a, b, c) From the Collection of the Rochester Public Library Local History Division; xvi(a) © Olga Lyubkina/Shutterstock; xvi(c, f) © Glenda M. Powers/Shuttertock

Illustration
i © Jennifer Thermes/Photodisc/Getty Images

ISBN 978-1-4396-0093-1
Library of Congress Catalog Card Number: 2010935893

Published by Arcadia Publishing, Charleston, SC
For all general information contact Arcadia Publishing at:
Telephone 843-853-2070
Fax 843-853-0044
Email sales@arcadiapublishing.com
For Customer Service and Orders:
Toll-Free 1-888-313-2665

Visit us on the Internet at www.arcadiapublishing.com

Table of Contents

Rochester

New York

Spotlight on Rochester!

Rochester sits at the mouth of the Genesee River on the south shore of Lake Ontario in upstate New York. It was called Rochesterville when it was first settled in 1817.

 How many people call Rochester home?

 The population within the city limits is around 207,000. But the metropolitan area (the city and surrounding area) is home to more than 1,000,000 people.

 Are there any sports teams in Rochester?

 Absolutely! Rochester fans love to support their teams, including the Rochester Red Wings (baseball), the Americans (ice hockey), the Rhinos (soccer), and the Knighthawks (lacrosse).

 What's one thing every kid should know about Rochester?

 Long ago, glaciers up to two miles thick covered the Rochester area. After the last glacier retreated, many natural wonders (from waterfalls to wetlands) were left behind.

At nearby Ontario Beach Park, you can ride one of the 52 hand-carved animals on a carousel that's been there since 1905.

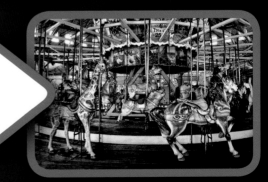

Rochester...

By The Numbers

1921

In that year George Eastman (who founded the Eastman Kodak Company) established the Eastman School of Music as part of the University of Rochester. It's now considered one of the best music schools in the world.

25,000

The Rochester Children's Theatre entertains more than 25,000 students each year at their school matinee performances.

8,900

The Strasenburgh Planetarium has a giant star projector that shows the sun, moon, planets, and 8,900 stars as they would look to you on a clear night from any point on Earth.

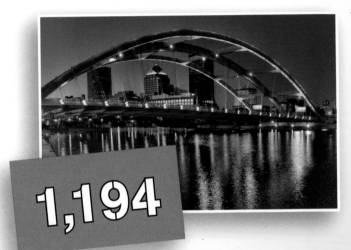

1,194

The Frederick Douglass–Susan B. Anthony Memorial Bridge is 1,194 feet long. This triple-arch bridge carries Interstate 490 over the Genesee River in downtown Rochester. It is named for two of the most important civil rights pioneers in the United States—both of whom lived in Rochester and are now buried in the city's Mt. Hope Cemetery.

More Numbers!

225,000	About 225,000 people attend the Fairport Canal Days Festival held along the banks of the historic Erie Canal in nearby Fairport.
1888	In that year, George Eastman introduced a small camera to the public that made photography simple for everyone.
96	Water drops 96 feet over the High Falls in Rochester.

Rochester: Sights and Sounds

Hear

...screams of delight from the Seabreeze Amusement Park. The park first opened in 1879 as the final stop on a steam railroad line. According to its web site, the Park is officially listed as the fourth oldest amusement park in the country!

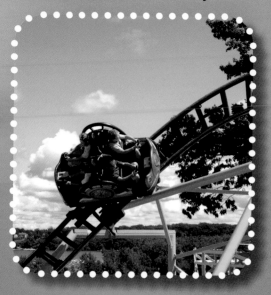

Smell

...the great scent of grilled white hots—Rochester's very own variety of hot dog. (Zweigle's has been selling them since 1925.)

...the sweetness of lilacs during Highland Park's beautiful Lilac Festival.

See

...the home of Susan B. Anthony, who helped women win the right to vote.

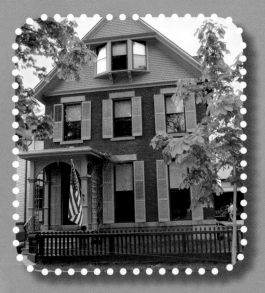

...the century-old Public Market where fresh food and other items are sold all year long.

Explore

...The Strong—an amazing institution that is dedicated to the study and exploration of play!

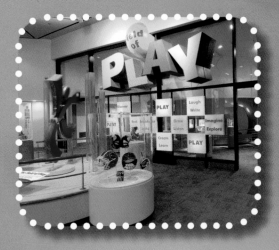

...the interactive exhibits at the Rochester Museum & Science Center. You can stare up at a mastodon or scale up a climbing wall—the choice is yours!

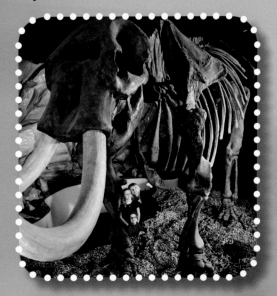

Sights and Sounds

STRANGE BUT TRUE!

A POLE WITH A STORY

Rochester has had a Liberty Pole standing downtown at the same site (in what is now called Liberty Pole Plaza) for more than 160 years. What's a Liberty Pole? It's a symbol that's been used since early colonial times to celebrate victories and to serve as a site for rallies, protests, and political campaigns. The current Liberty Pole, built in 1965, is a stainless steel structure designed by a Rochester architect.

OLIVE THE RIGHT NAMES

The Seneca Park Zoo has a wide variety of animals—including a troop of olive baboons. Interestingly, many of the animals in the troop are named after different kinds of olives. Some favorite names? "Pimento," "Stuffed," and "Kalamata," of course!

SNAKES ALIVE!

Rattlesnake Pete (Peter P. Gruber) was a famous fellow in Rochester in the early twentieth century. He caught and handled snakes, wore snakeskin clothing, and kept tanks of live snakes and other curious things for people to see. Although Rattlesnake Pete was bitten by venomous snakes dozens of times, he lived to see his 75th birthday.

Strange But True

Rochester: Marvelous Monikers

What's a moniker? It's another word for a name...and Rochester has plenty of interesting monikers around town!

Wegmans

A Tasty Name

The roots of **Wegmans** famous supermarket chain go back to 1916 when John Wegman opened the Rochester Fruit & Vegetable Company.

Swillburg

A Swell Name

Legend has it that the neighborhood of **Swillburg** got its name when a 19th-century pig farmer collected food scraps from the area to make swill (feed) for his swine.

O'Rorke

An Honored Name

Patrick **O'Rorke** grew up in Rochester and graduated first in his class from West Point in 1861. Although O'Rorke was killed just a couple years later in the Civil War, he was never forgotten. In 2004, the Colonel Patrick H. O'Rorke Bridge (spanning the Genesee River) was dedicated to his memory.

Kodak

A Picture Perfect Name!

George Eastman invented the word **Kodak**. The letter k was a favorite of his—so that letter was chosen to begin and end the word. (The rest of the letters fell into place after trying many different combinations!)

Flour and Flower

Changing Names

Although Rochester was first known for its flour milling, by the mid-1800s the city was also famous for its nursery and seed industry. Thus, the **Flour** City became the **Flower** City, and both are names you'll see in Rochester today.

Rochester: DRAMATIC DAYS

A BIG Change

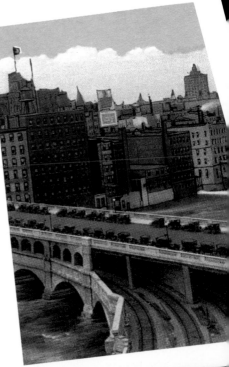

What do you do when a canal meets a river? You take the canal over the river and drop it down on the other side. That's what the Erie Canal Aqueduct did when it was built over the Genesee River in 1823. But the story doesn't end there. When the Erie Canal was moved south of the city, the aqueduct was no longer needed. So in 1924 a road (Broad Street) was built on top of it. Later, train tracks were built through the aqueduct to form the Rochester Subway (or Rochester Industrial and Rapid Transit Railway), which operated until 1956.

An Icy Storm!

March 3, 1991, was an unusually warm day for Rochester. Then came a cold front, and by evening, freezing rain began to fall, coating trees and wires with an inch or more of ice. Throughout the night, tree limbs cracked and broke—and brought down power lines with them. Although crews worked around the clock, it took two weeks to restore power to everyone. Nearly half the city's trees were damaged, and about 14,000 were removed and replaced over the next four years.

A GREAT Flood

In the spring of 1865, the temperature suddenly rose after a long period of cold and snow. Runoff from the Genesee River and the Erie Canal flooded downtown Rochester. Bridges and buildings were swept away and damage was estimated at a million dollars— which was considered even more money back then than it is now!

Congratulations!

You have just completed a kid-sized tour of Rochester... but there's more to explore!

The city of Rochester is an important part of the state of New York. Why? It's because the city helps shape the state and the state helps shape the city!

Read on to find out more...

New York

What's So Great About This State?

There is a lot to see and celebrate...just take a look!

CONTENTS

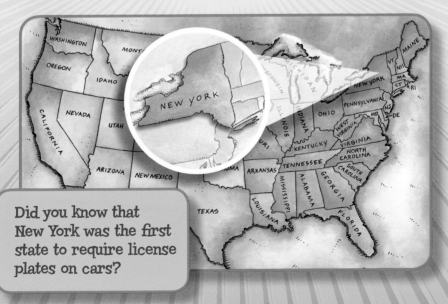

Did you know that New York was the first state to require license plates on cars?

Well, how about...
the land!

Upstate

Talk about changing beauty! The state of New York is loaded with different types of landforms—from coastal beaches to inland mountains, valleys, and plateaus.

Hardwood forests explode in shades of red, orange, and yellow when leaves turn color in the fall. Rolling hills and farmland form picture-perfect landscapes. Freshwater lakes and rivers send water tumbling over waterfalls on its way from mountains to sea.

The upstate area claims the highest land in the Empire State. Mount Marcy, the highest peak in the Adirondack Mountains, towers 5,344 feet above sea level.

Lake Ontario forms part of the border with Canada.

A farm stands among the trees in the Catskills of New York.

Downstate

However, follow the Hudson River downstate, and the land will begin to get lower. The natural beauty of the wide Hudson River Valley is dotted with charming cities and villages. But when you arrive at the mouth of the Hudson, you'll find the largest city in the United States—New York City. Amazingly, this huge city stretches across land (and islands!) that sit just a little above sea level.

It's quite an adventure to explore the land across New York State. Take a closer look at the next few pages to see just some of the interesting places you can visit.

The Brooklyn Bridge crosses the East River in New York City.

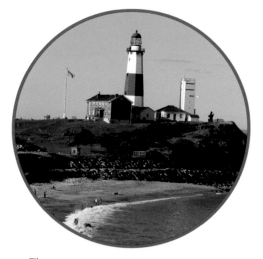

The Montauk Point Lighthouse on Long Island is the oldest in the state.

The fall color is beautiful in upstate New York.

Lakes and Rivers

This peaceful lake is in Adirondack State Park.

The state of New York is known for its many beautiful lakes and rivers! In fact, most of the state's northern border with Canada is formed by lakes and rivers. Which ones? The border includes the Great Lakes of Ontario and Erie and the Niagara and St. Lawrence rivers.

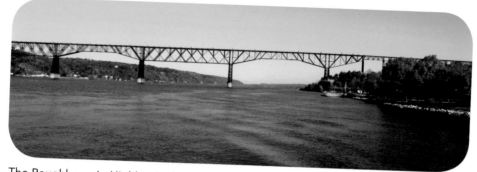

The Poughkeepsie-Highland Railroad bridge has been converted into a pedestrian walkway over the beautiful Hudson River.

Why are lakes and rivers so special?

Lakes and rivers provide recreation, transportation, food, and habitats. They also provide some interesting clues about how the land was formed.

For example, do you know that New York State has eleven fingers? Okay—they're not real fingers. They're actually eleven long lakes on the northern edge of the Appalachian Upland area. From a bird's-eye view, these lakes look like fingers on a pair of outstretched hands. So, of course, that's why they're called the Finger Lakes!

So how did the Finger Lakes form?

Thousands of years ago, the state was nearly completely covered with glaciers. These huge sheets of ice carved deep valleys and gorges in the land. When the last of the glaciers retreated (about 11,000 years ago) they left the Finger Lakes behind!

And don't forget...

Rivers are really important highways. People and their "stuff" can move many miles on the river system throughout New York State. For example, both the St. Lawrence and Hudson rivers allow people even from the most northern parts of the state to travel all the way to the Atlantic Ocean.

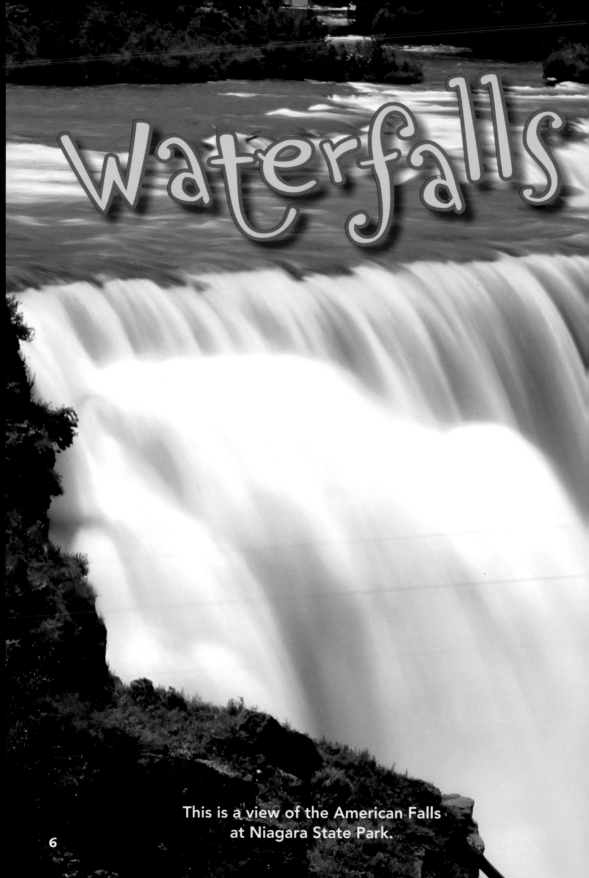

Waterfalls

This is a view of the American Falls
at Niagara State Park.

The spectacular natural wonder of Niagara Falls—with waterfalls on both the Canadian and American sides—attracts millions of visitors each year.

Where does all that water come from? (...and where is it going?)

Four of the five Great Lakes send water through the amazing Niagara Falls. Water moves from Lake Superior, Lake Michigan, and Lake Huron into Lake Erie. From Lake Erie, water flows through the Niagara River and Niagara Falls on its way to Lake Ontario. After it leaves Lake Ontario, the fresh water travels through the St. Lawrence River before it finally mixes with the salty ocean water of the Atlantic.

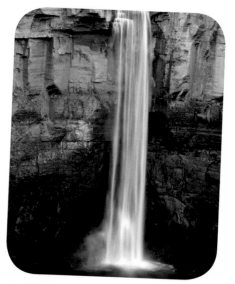

At 215 feet, the Taughannock Falls near Ithaca are about 32 feet higher than Niagara Falls.

Does the state have other waterfalls?

Kaaterskill, She-Qua-Ga, Pixley—these are just a few of the names of the many waterfalls in New York. Waterfalls come in all shapes and sizes. Many are found in gorges throughout the state.

What's a gorge?

It's a steep, narrow valley with rocky sides that often has water flowing through it. Just visit the Genessee River Gorge or the famous Watkins Glen Gorge and you will be amazed at the beautiful waterfalls you see!

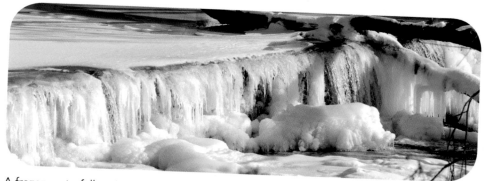

A frozen waterfall on Wappinger Creek in Dutchess County, New York.

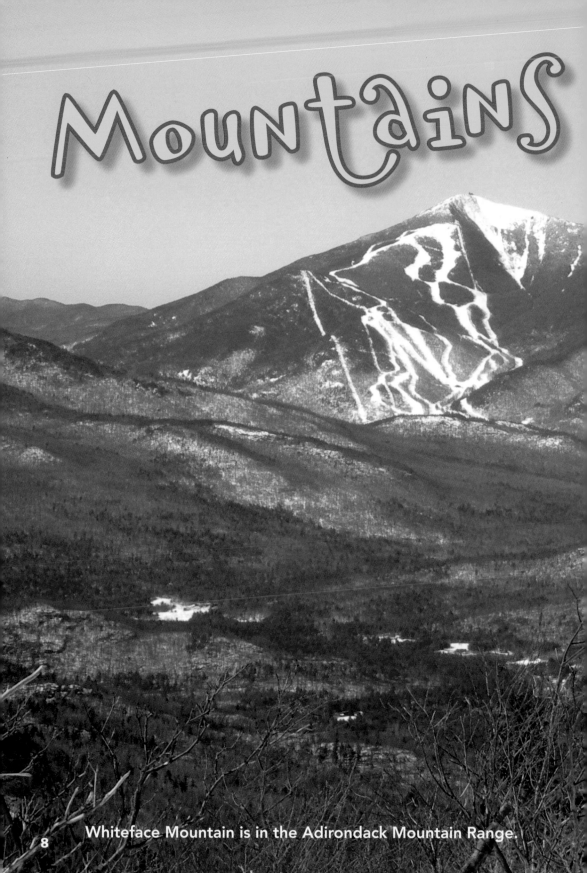

MounTains

Whiteface Mountain is in the Adirondack Mountain Range.

Much of New York is loaded with majestic mountain ranges. The Adirondack, Catskill, and Allegheny mountains are part of why the state is so exciting to explore—in any season!

What's so special about the Adirondack Mountain area?

For one thing…this mountain range in the northern part of the state is part of the largest park in the country. At 6.1 million acres, the Adirondack Park is larger than Yellowstone, Yosemite, Glacier, the Grand Canyon, and the Great Smoky Mountain parks all combined! From fishing on Lake Champlain to hiking the more than 2,000 miles of trails, there's plenty to do and see in the Adirondacks.

What's the Catskills claim to fame?

The area has woodlands, wildlife, and even literary fame. Washington Irving set his famous story about Rip Van Winkle in the Catskills. The story is about a man who went to sleep for 20 years. Good thing it was fiction. It would be a real shame to sleep for so long in an area with so much to do!

What kinds of critters can I see in the mountains?

Wild turkeys, trout, fox, porcupines, beavers, hawks, eagles, and lots of white-tailed deer live in the mountain regions.

Snowboarders and skiers love New York!

Don't forget the black bears!

It's probably good if you never see one, but New York is home to a large population of black bears—more than 6,000 of them! The Adirondack, Catskill, and Allegheny ranges have the largest populations. Why do bears prefer these places? One reason is that the mountains have forest areas rich in berries and nuts—which black bears love to eat.

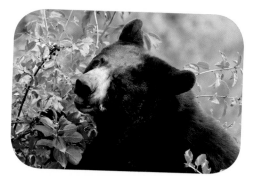

Black bears love New York, too!

Well, how about...
the history!

Tell Me a Story!

The story of New York began thousands of years ago. Following the tradition of their ancestors who first lived on the land, Native Americans made their homes throughout the state. The Haudenosaunee (People of the Longhouse— also called the Iroquois) and the Algonquian were the two main groups living in New York state in the late 1400s. Descendants from many of the tribes in these groups still live throughout the state today.

These Seneca buckskin moccasins are decorated with tiny glass beads.

You often hear people speak the names of Native American tribes because many places throughout the state are named in their honor. Oneida and Onondaga counties, the Mohawk River, Seneca Lake, and Montauk Point—these names all honor the people who first lived on Empire State land so long ago.

...The Story Continues

Eventually, New York became home to many other groups, including Dutch, British, and French explorers; European and American settlers; and African Americans. Many battles for independence were fought in New York. In fact, New York was one of the main battlegrounds during the Revolutionary War.

But history isn't always about war. New Yorkers have always educated, invented, painted, written, sung, and built. Many footprints are stamped into the soul of New York's history. You can see evidence of this all over the state!

New York State was one of the 13 original colonies. Key battles fought in the state helped lead to American independence.

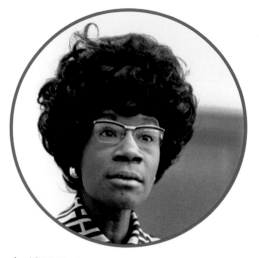

In 1968 Shirley A. Chisholm became the first African American woman to serve in Congress when she was elected to the U.S. House of Representatives. She was born in Brooklyn, New York.

This house in Newburgh was George Washington's headquarters at the end of the American Revolution.

Monuments

One of the most famous monuments in the world
is the Statue of Liberty in New York City.

Monuments honor special people or events. The Statue of Liberty was a gift from France in celebration of the 100th birthday of the Declaration of Independence. It became a symbol of freedom to people all over the world.

Why are New York monuments so special?

That's an easy one! The hundreds of monuments (and memorials) throughout the state honor soldiers, poets, politicians, and "extraordinary" ordinary people who helped shape both the state of New York and the nation.

What kinds of monuments can I see in New York?

There are statues, plaques, markers, cornerstones, named bridges and streets—almost every town has found some way to honor a historic person or event.

Where are monuments placed?

Anyplace where something important happened! For example, in 1848 a small group of women (including Elizabeth Cady Stanton, Lucretia Mott, Martha Wright, Mary Ann McClintock, and Jane Hunt) organized a convention in support of women's rights. The Women's Rights National Historical Park in Seneca Falls, New York, now honors these women—and others—who supported equal rights for women.

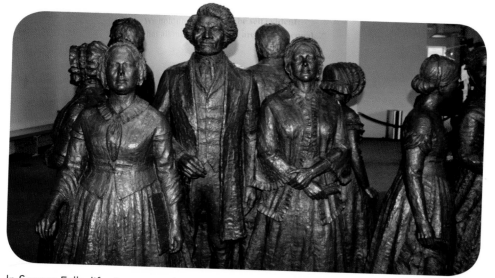

In Seneca Falls, life-size statues honor the organizers (and a few of the men who supported them!) of the first Women's Rights Convention.

MUSEUMS

It's interesting to explore the dinosaur exhibits at the American Museum of Natural History in New York City.

Museums don't just tell you about history—they actually show you artifacts from times past. Artifacts can be actual objects or models of objects. Either way, they make history come alive!

Why are the museums throughout New York State so special?

New York museums contain amazing exhibits with artifacts that tell the story of the state. The New York State Museum in Albany tells about the state's rich history and its progress in arts and culture. The museum is more than 170 years old. It has more than 12 million artifacts and specimens!

The Erie Canal Museum in Syracuse tells the story of the first all-water route from the East Coast to the Great Lakes. This waterway (completed in 1825) opened the door for transportation and settlement throughout upstate New York.

What can I see in a museum?

An easier question to answer might be "What can't I see in a museum?" There are thousands of items exhibited in all kinds of different museums across the state. Are you a baseball fan? Then the National Baseball Hall of Fame and Museum in Cooperstown is for you! Do you like art? The Met (short for The Metropolitan Museum of Art) in New York City is one of the largest art galleries in the world.

You can learn about the art of glass making at the Corning Museum of Glass in Corning, New York.

A full-size carousel is on display at the New York State Museum.

Forts

Fort Stanwix became known as "the fort that never surrendered" because Americans successfully held off a British attack that lasted several weeks.

Travel the Revolutionary War Heritage Trail and it will lead you to Fort Stanwix in Rome, New York. It was here in 1777 that Continental soldiers, local fighters, and Oneida Indian allies held off the British. This success helped to bring about American victories at the Battles of Saratoga, which would be a turning point in the American Revolution.

Why are forts special? (...and what is a fort, anyway?)

A fort is a defensive structure built for troops. Forts were often constructed on high ground along an important transportation route. They played important roles in the struggles of France, Great Britain, and the United States in the New World.

The inside of a fort was a self-contained community. Remember, soldiers had to stay inside the fort during long attacks! A fort had barracks— places for soldiers to sleep—as well as kitchens for water and food supplies. Forts even had repair shops to keep battle equipment in top shape.

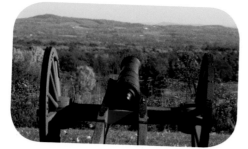

You can see artifacts, like this American Revolutionary War cannon, at some forts.

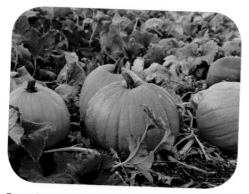

Pumpkins now grow in the Discovery Gardens at Fort Ticonderoga. This fort was built by the French at the south end of Lake Champlain between 1754 and 1757.

What can I see if I visit a fort?

Some forts show you what life was like hundreds of years ago. You can see artifacts, including cannons and other weapons soldiers used. You can also see the rooms where the soldiers ate and slept. At some forts there are even reenactments of battles.

...and there's more!

Some forts today grow beautiful gardens. Other forts have battlefields or parks where you can sightsee, picnic, hike, and bike.

Well, how about...
the people!

Enjoying the Outdoors

Nearly 20 million people live in the Empire State. Though they have different beliefs and traditions, New Yorkers also have plenty in common.

Many share a love of the outdoors. Some of the best places for enjoying the great outdoors in New York are in the national and state parks. And since New York has four seasons, choices for activities change all year long. Hiking in the fall, skiing in the winter, whitewater rafting in the spring, swimming in the summer—the list of things that New Yorkers enjoy goes on and on!

Apple picking is a fun fall activity in the state of New York.

Ice skating is popular in winter throughout the state of New York.

Sharing Traditions

In the towns and cities throughout the state, New Yorkers share the freedom to celebrate different heritages. The great mix of cultures makes the state an interesting and exciting place to live.

Did you ever wonder what a Revolutionary War battle was like? New Yorkers often re-create battles to honor the history and heritage of brave soldiers. Cooking is another way to pass on traditions. Have you tried Middle Eastern falafel sandwiches or Vietnamese egg rolls? What about German bratwurst, Mexican tacos, or New York style pizza? These foods come from many cultures, but they are all served at New York tables.

Visitors join the celebration during the Pinkster Festival at Philipsburg Manor in Sleepy Hollow, New York.

Hispanic cuisine is very popular throughout many different areas in New York.

Autumn is beautiful in the Adirondacks.

Protecting

The state's Department of Environmental Conservation helps protect American bald eagles.

Protecting all of New York's natural resources is a full-time job for many people!

Why is it important to protect New York's natural resources?

The state of New York is more than 275 miles wide, so that means there are a lot of different environments within its borders. The land changes from sandy shores to rolling hills, from mountains and deep valleys to flat plateaus covered in thick forests. All of these different environments mean many different plants and animals can live throughout the state. In technical terms, New York has great biodiversity! This biodiversity is important to protect because it keeps the environments balanced and healthy.

What kinds of organizations protect these resources?

It takes lots of groups to cover it all. The U.S. Fish and Wildlife Service is a national organization. The New York State Office of Parks, Recreation, and Historic Preservation is a state organization. And there are others. The Wildlife Conservation Society was one of the first conservation organizations in the country. This society has created four zoos and an aquarium in New York City.

And don't forget...

You can make a difference, too! It's called "environmental stewardship," and it means that you are willing to take personal responsibility to help protect New York's natural resources.

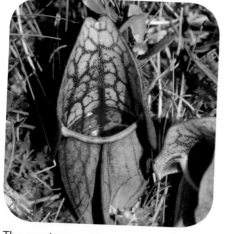

The carnivorous (insect-eating) pitcher plant grows in the Quogue Wildlife Refuge on Long Island.

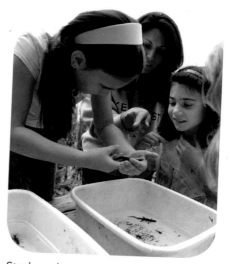

Students learn about aquatic "critters" during a class at the Taconic Outdoor Education Center.

Creating Jobs

New York State ranks third in the
nation in dairy production.

Some jobs, such as farming, have been done in New York for a long time. Other jobs, such as those in the high-tech industry, are growing in demand.

What kinds of jobs are found throughout the state?

New Yorkers have always been good at making things. From manufacturing to information technology, great products are being developed all over the state.

Albany, the state's capital, and the Hudson Valley are centers for nanotechnology and microchip manufacturing. New York City is well known for its garment and publishing industries.

New York City is also the leading banking and financial center of the country. Have you heard of Wall Street? It's one of the most famous streets in the world because it is home to the New York Stock Exchange.

May I help you?

Another big industry is the service industry. Many jobs are needed to help millions of tourists sightsee, dine, and relax!

Don't forget the military!

The Air Force, Army, Navy, Marine Corps, and Coast Guard all have a presence in the state. Whether training or working, the brave men and women who serve our country are held in great respect throughout New York.

Although New York City is known as the Big Apple, it's the whole state that takes the prize. New York State grows more apples than any other state except Washington.

New York is home to leading financial centers.

Military training is hard work!

Celebrating

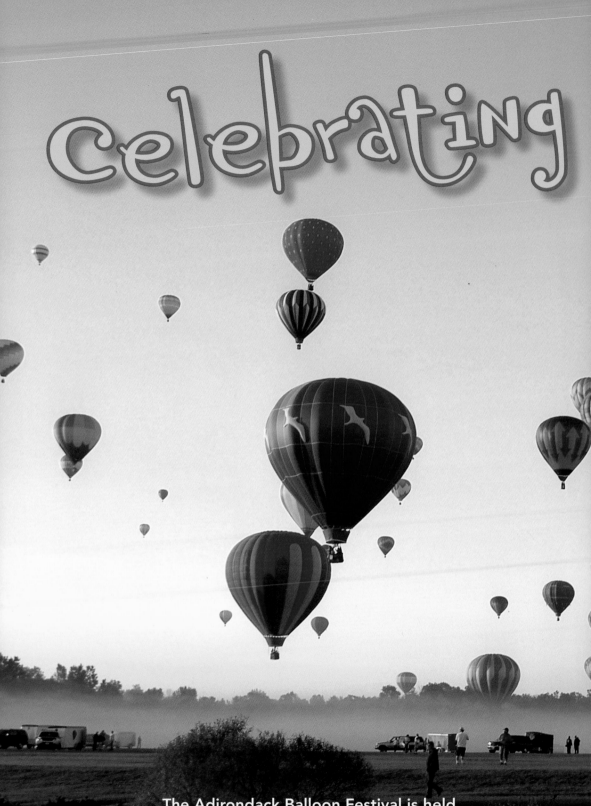

The Adirondack Balloon Festival is held each year in Glens Falls, New York.

The people of New York really know how to have fun! For almost four decades, hot-air balloons have been rising each year at the Adirondack Balloon Festival. The Great New York State Fair in Syracuse has been an annual event for more than 160 years—which makes it the oldest state fair in the United States.

You can hear great jazz at the Saratoga Springs Jazz Festival.

The first Macy's Thanksgiving Day parade was held more than 80 years ago.

Why are New York festivals and celebrations special?

Celebrations and festivals bring people together. From cooking contests to art shows, events in every corner of the Empire State showcase all different kinds of people and talents.

What kind of celebrations and festivals are held in New York?

Too many to count! But one thing is for sure, you can find a celebration or festival for just about anything you want to do.

Want to see some gorgeous flowers? The Albany Tulip Festival celebrates the city's Dutch heritage with an awesome display of tulips each spring.

Do you like jazz or rhythm and blues? Then try the Saratoga Springs Jazz Festival.

...and don't forget THE Parade!!

The famous Macy's Thanksgiving Parade draws 3 million people to the streets of New York City —and another 44 million watch it on TV!

Birds and Words

What do all the people of New York have in common? These symbols represent the state's shared history and natural resources.

State Bird
Eastern Bluebird

State Tree
Sugar Maple

State Flower
Rose

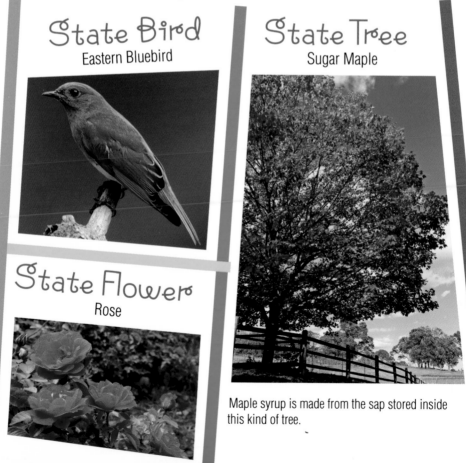

Maple syrup is made from the sap stored inside this kind of tree.

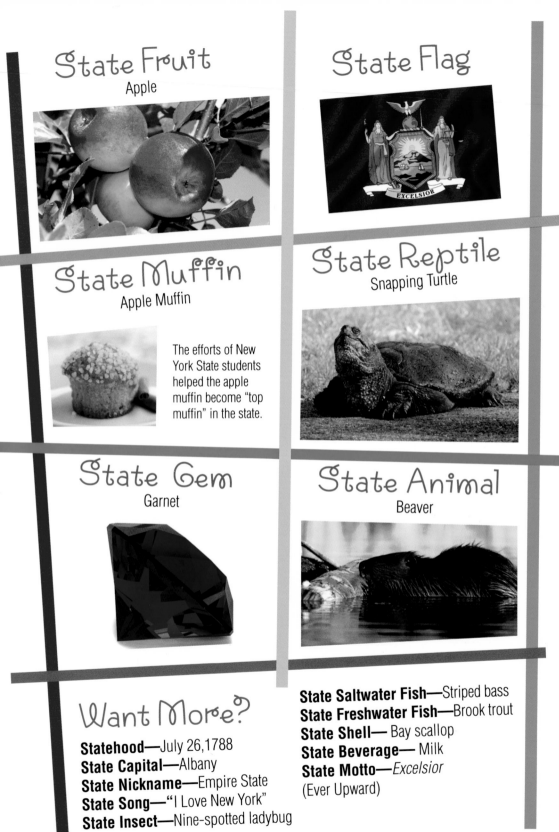

State Fruit
Apple

State Flag

State Muffin
Apple Muffin

The efforts of New York State students helped the apple muffin become "top muffin" in the state.

State Reptile
Snapping Turtle

State Gem
Garnet

State Animal
Beaver

Want More?

Statehood—July 26,1788
State Capital—Albany
State Nickname—Empire State
State Song—"I Love New York"
State Insect—Nine-spotted ladybug

State Saltwater Fish—Striped bass
State Freshwater Fish—Brook trout
State Shell— Bay scallop
State Beverage— Milk
State Motto—*Excelsior*
(Ever Upward)

More Fun Facts

More
Here's some more interesting stuff about New York!

Welcome Stop
Ellis Island in New York Harbor was the first stop for many immigrants coming to America. Today, visitors tour the Ellis Island Immigration Museum.

International Neighbors
The Great Lakes of Erie and Ontario along with the St. Lawrence River form the northern border of the state with Canada.

More Neighbors
Vermont, Massachusetts, Connecticut, New Jersey, and Pennsylvania share borders with New York State. And the Atlantic Ocean is part of the state's southeastern border.

A Famous Name
The Hudson River, Hudson Strait, and Hudson Bay are all named after the English explorer Henry Hudson.

Let It Snow!
Five cities in central and upstate New York—**Albany**, **Buffalo**, **Binghamton**, **Rochester** and **Syracuse**—compete each year for The Golden Snowball Award. It's a prize awarded to the city that gets the most total inches of snow!

Ex Capital
For a few of the early years in the country's history, **New York City** served as the capital of the United States.

All Aboard!

Although only 11 miles long, the first railroad in the United States ran between **Albany** and **Schenectady**.

Take a Seat

There are more than 9,000 park benches in New York City's Central Park for the 25 million visitors it receives each year.

Yellow Brick Road

Chittenago, New York was the home of L. Frank Baum, the man who wrote *The Wonderful Wizard of Oz*.

Top Shelf

Melvil Dewey of **Adams Center** created the Dewey Decimal System for classifying materials in libraries.

A Royal Flush

Joseph C. Gayetty of **New York City** produced the first packaged toilet paper in the United States in 1857. (His name was printed on every sheet!)

Freedom Stop

Frederick Douglass, once an enslaved person himself, used his own home in **Rochester**, New York as a stop on the Underground Railroad.

Three In One

Niagara Falls actually consists of three separate falls: the American Falls, the Bridal Veil Falls, and the Horseshoe Falls (sometimes called the Canadian Falls).

Lake Monsters

Legend has it that **Lake Champlain** hosts an unknown creature of the deep—named Champ! Another lake monster, George, surfaced in **Lake George** in 1904— but it was a well-documented practical joke!

Up the River

Unlike most other rivers, the **Genesee** and **Oswego Rivers** in New York flow north! (actually downhill in a northerly direction.)

Islands Galore!

More than 1,000 islands (literally!) dot the St. Lawrence River and the eastern shores of Lake Ontario in the Thousand Islands region of Canada and the United States.

Rock On

The famous 1969 Woodstock Music Festival was actually held on a 600-acre farm in the township of **Bethel**, New York.

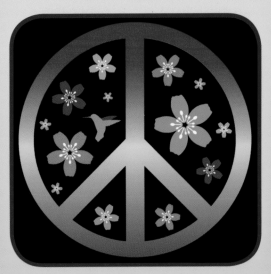

Find Out More

There are many great websites that can give you and your parents more information about all the great things that are going on in the state of New York!

State Websites

The Official Website of the State of New York
www.ny.gov

New York State Parks
www.nysparks.com

The Official Tourism Site of New York
www.iloveny.com

Museums

New York City

Metropolitan Museum of Art
www.metmuseum.org

American Museum of Natural History
www.amnh.org

Guggenheim Museum
www.guggenheim.org

Albany

New York State Museum
www.nysm.nysed.gov

Brooklyn

Brooklyn Children's Museum
www.brooklynkids.org

Buffalo

Buffalo Museum of Science
www.sciencebuff.org

Howes Cave

Iroquois Indian Museum
www.iroquoismuseum.org

Jamestown

Lucy-Desi Museum
www.lucy-desi.com

Rochester

Strong National Museum of Play
www.museumofplay.org

Aquariums and Zoos

Aquarium of Niagara (Niagara Falls)
www.aquariumofniagara.org

New York Aquarium (New York City)
www.nyaquarium.com

Bronx Zoo (New York City)
www.bronxzoo.com

Utica Zoo (Utica)
www.uticazoo.org

New York: At A Glance

State Capital: Albany

New York Borders: Vermont, Massachusetts, Pennsylvania, Connecticut, New Jersey, Canada, and the Atlantic Ocean

Population: Over 19 million

Highest Point: Mount Marcy is 5,344 feet (1,629 meters) above sea level

Lowest Point: Sea level at the Atlantic Ocean

Some Major Cities: New York, Buffalo, Rochester, Syracuse, Albany

Some Famous New Yorkers

James Baldwin (1924-1987) from Harlem; was an important author who wrote extensively about the Civil Rights Movement.

Bonnie Blair (born 1964) from Cornwall; is an athlete who won Olympic speed skating medals and is in the Olympic Hall of Fame.

Lucille Ball (1911-1989) from Jamestown; was a popular comedian who starred in the "I Love Lucy" show.

George Eastman (1854-1932) from Waterville; was an inventor and businessman who founded the Eastman Kodak Company.

Winifred Goldring (1888-1971) from Kenwood; was a paleontologist and geologist who became the first female State Paleontologist for New York.

Julia Ward Howe (1819-1910) from New York; was a social activist, writer, and poet.

Madeleine L'Engle (1918-2007) from New York; was an award- winning author of children's books.

Ely S. Parker (1828-1895) from Indian Falls; was a member of the Seneca Nation who served as an attorney, engineer, tribal diplomat, and brigadier general in the Civil War.

Franklin D. Roosevelt (1882-1945) from Hyde Park; was elected president of the United States in 1932—for the first of four terms.

Jonas Salk (1914-1995) from New York; was a scientist who discovered the first safe and effective polio vaccine.

Neil deGrasse Tyson (born 1958) from New York; is an astrophysicist and director of the Hayden Planetarium.

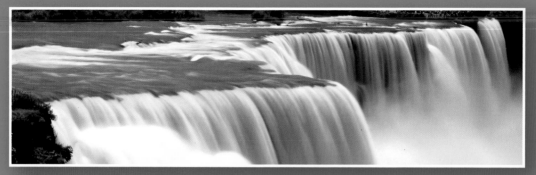

The American Falls are a beautiful part of Niagara Falls.

CREDITS

Series Concept and Development
Kate Boehm Jerome

Design
Steve Curtis Design, Inc. (www.SCDchicago.com); Roger Radtke, Todd Nossek

Reviewers and Contributors
Stacey L. Klaman, writer and editor; Mary L. Heaton, copy editor; Eric Nyquist, researcher; Hadley Horrigan, V.P. Public Affairs, Buffalo Niagara Partnership

Photography
Back Cover(a), 22-23 © verityjohnson/Shutterstock; Back Cover(b), 24-25 © Jim Lozouski/Shutterstock; Back Cover(c), 3a © Joshua Haviv/Shutterstock; Back Cover(d), 2-3 © Peter Knif/Shutterstock; Back Cover(e) © Matt Wade; Cover(a), 6-7, 32 © Kevin Tavares/Shutterstock; Cover(b), 26 © Chamille White/Shutterstock; Cover(c), 27 © Beneda Miroslav/Shutterstock; Cover(d), 3b © MISHELLA/Shutterstock; Cover(e), 26 © Steve Byland/Shutterstock; Cover(f) © Donald R. Swartz/Shutterstock; 2a © Henry Hazboun/Shutterstock; 2b © Liz Van Steenburgh/Shutterstock; 4-5 © Johnathan Esper/Shutterstock; 5a © Nancy Kennedy/Shutterstock; 7a © Olga Bogatyrenko/Shutterstock; 7b Courtesy Juliancolton/Wikimedia; 8-9 Courtesy petersent/Wikimedia; 9a © J. Cameron Gull/Shutterstock; 9b © nialat/Shutterstock; 10-11 Courtesy PIPC Archives; 10a NYSM E-36655A-B. © the New York State Museum, Albany, NY; 11a © Lawrence Roberg/Shutterstock; 11b Courtesy Library of Congess; 12-13 © Gary Blakeley/Shutterstock; 13a NPS Photo; 14-15 Image #6745 by J. Beckett/American Museum of Natural History Library; 15a Courtesy The Corning Museum of Glass, Corning, NY; 15b NYSM H-1975.134.1. © the New York State Museum, Albany, NY; 16-17 © David Campbell; 17a © Sean Donohue Photo/Shutterstock; 17b © L.L.Masseth/Shutterstock; 18-19 © Doug Lemke/Shutterstock; 18a Courtesy New York Apple Association; 18b © umbro68/Shutterstock; 19a © Bryan Haeffele for Historic Hudson Valley/hudsonvalley.org; 19b © Evok20/Shutterstock; 20-21 © Matt Ragen/Shutterstock; 21a © Dennis Donohue/Shutterstock; 21b © John Rozell/Courtesy New York State Office of Parks, Recreation, and Historic Preservation; 23a © Lana Langlois/Shutterstock; 23b © Monkey Business Images/Shutterstock; 23c © John Wollwerth/Shutterstock; 25a © Pindyurin Vasily/Shutterstock; 25b © Abdel Berraha; 26b © Lori Froeb/Shutterstock; 27b © Rene Grycner/Shutterstock; 27c © Kati Molin/Shutterstock; 27d © drewthehobbit /Shutterstock; 27e © Igor Kaliuzhnyi/Shutterstock; 27f © Jason Kasumovic/Shutterstock; 28 © Bonita R. Cheshier/Shutterstock; 29a © silver-john/Shutterstock; 29b © EveStock/Shutterstock; 31 © R. Gino Santa Maria/Shutterstock

Illustration
Back Cover, 1, 4 © Jennifer Thermes/Photodisc/Getty Images

ISBN 978-1-58973-014-4

Library of Congress Catalog Card Number: 2009943369

1 2 3 4 5 6 WPC 15 14 13 12 11 10

Published by Arcadia Publishing
Charleston SC, Chicago IL, Portsmouth NH, San Francisco CA

For all general information contact Arcadia Publishing at:
Telephone 843-853-2070
Fax 843-853-0044
Email sales@arcadiapublishing.com
For Customer Service and Orders:
Toll Free 1-888-313-2665

Visit us on the Internet at www.arcadiapublishing.com